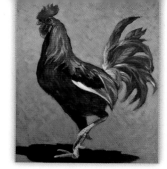

Acrylic Basics

Whether you've never picked up a paintbrush or you're an experienced painter just looking for some new information, I want to give a warm welcome to you. I hope this book is the start of a love affair with painting that will bring you joy for many years to come. I believe the only really important skill for beginning art students is enthusiasm. Everything else can be learned if you are willing to put in the time, keep an open mind, and work your way through the challenges. I'm not saying it's easy—for most of us, including me, it's often challenging. However, the reward of creating something that's beautiful makes it worthwhile. My hope for this book is to give you some basic tools to get started. Take what feels right for you and leave the rest. Ultimately, creativity lies in figuring it out for yourself—that's how you do work that is truly yours, and that's what being an artist is all about. —*Janice Robertson*

CONTENTS

Walter Foster

TOOLS & MATERIALS

Painting is fun, frustrating, exhilarating, tedious, absorbing, and transformative. The tools and materials presented here are ones that I've found work well for me. Feel free to experiment, and choose the tools that you are most comfortable with.

PAINTS

There are two types of acrylic paint—fluid and heavy body. Fluid is liquefied and can be poured, while heavy body is the consistency of toothpaste. One is not better than the other, and the choice comes down to the artist's preference. For my own work and the examples in this book, I prefer heavy-body paint.

There are vast differences in the prices of different brands of acrylic paint. You generally get what you pay for. There are "artist-quality" paints and "student-quality" paints. I advise against getting cheap paint—the colors can be garish and the pigments are extended with fillers, which can dilute the intensity and cause a dull, muddy look.

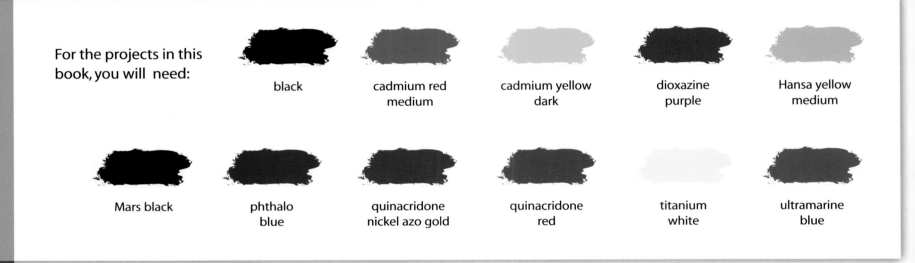

For the projects in this book, you will need:

black	cadmium red medium	cadmium yellow dark	dioxazine purple	Hansa yellow medium

Mars black	phthalo blue	quinacridone nickel azo gold	quinacridone red	titanium white	ultramarine blue

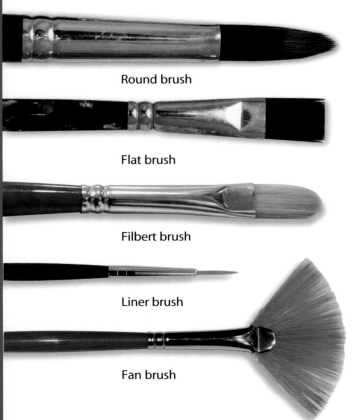

Round brush

Flat brush

Filbert brush

Liner brush

Fan brush

BRUSHES

Brushes come in different degrees of softness versus stiffness, and it's good to experiment with different types when starting out. Select the ones that you feel most comfortable with, and make sure you use synthetic brushes, as their strong filaments can withstand the caustic nature of acrylic paint.

PALETTES

A palette holds your paint and gives you an area for mixing. I prefer one large surface rather than multiple little sections. There are many palette options available—metal, plastic, paper, or glass. You can also use a white plate, a piece of glass with white paper under it, or a baking tray.

MEDIUMS

Mediums are products that can be added to paint to extend it or enhance the way the paint behaves. Depending on the medium, they can increase gloss, flow, or transparency and increase or decrease drying time. For the projects in this book, I recommend slow-drying and glazing mediums.

VARNISHES

A finished acrylic painting needs to be varnished, both to protect the artwork and give the painting an even amount of sheen. Varnishing makes your painting look more polished. Varnish comes in a spray or as a paint-on product. It also comes in many degrees of shine, from high gloss to matte. Be sure to varnish your paintings in a well-ventilated area, as the fumes can be toxic.

- [] **Water bucket**
 Acrylics make the water very dirty—a bigger bucket means fewer water changes
- [] **Small spray bottle**
 to keep paint from drying on the palette
- [] **Paper towels & tissues**
 for cleanup
- [] **Palette knife**
 Useful for scraping off dried paint from the palette
- [] **Apron**
 to protect clothing, as acrylic is extremely difficult to remove
- [] **Chalk**
 to sketch an initial drawing before you begin painting

ADDITIONAL SUPPLIES

COLOR THEORY

There are many books written on color theory, so this will be a very brief discussion of the basics. There are also many different theories—this is my version.

PRIMARY COLORS

The primary colors include yellow, red, and blue. All other colors are made up of a combination of these three colors. Primary colors cannot be created by mixing other colors together.

SECONDARY COLORS

Secondary colors are made by mixing two primary colors together. These include orange, violet, and green.

TERTIARY COLORS

Tertiary colors are made by mixing a primary color with its neighboring secondary color, such as yellow-orange, red-violet, and blue-green.

COLOR WHEEL

The color wheel helps us clearly see relationships between all the colors.

COMPLEMENTARY COLORS

Each primary color has a complementary color that sits opposite from it on the color wheel. The complement of each color is a mixture of the other two primaries.

NEUTRAL COLORS

Neutral colors are made by mixing all three primaries together and are often dulled with white or black.

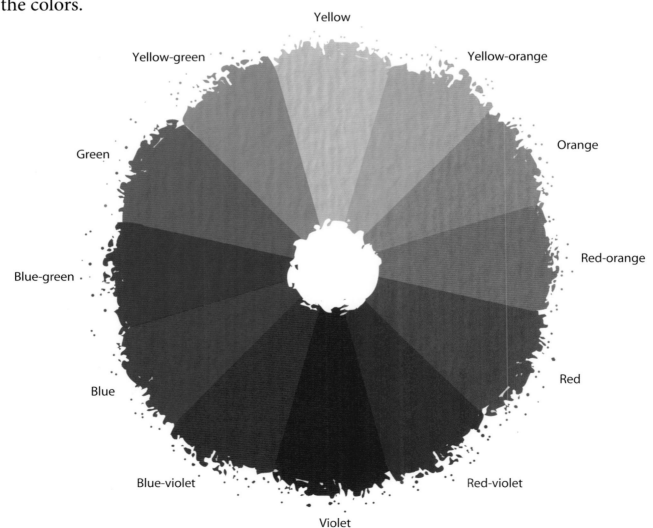

PIGMENTS

Pigment comes as a powder in its pure form and is suspended in acrylic polymer resin to create artist's acrylic paint. Each color has its own characteristics or properties. Some pigments are transparent and others are opaque. Some are very intense and concentrated and others are more delicate. It is important to understand the different properties of the pigments you're working with so that you know which ones will give you the effect you're looking for.

Transparent non-staining pigments are delicate with very little covering power. When mixed with opaque or staining colors they can be overwhelmed. They are good for glazing and can be mixed with white to create soft pastel colors. Some examples include: Hansa yellow medium, cobalt blue, burnt sienna, and viridian.

Opaque, or sedimentary, pigments are dense with good covering power. Some examples include: titanium white, yellow ochre, cerulean blue chromium, pyrrole red, and all cadmiums.

Transparent staining pigments are very intense, transparent pigments that can overpower other colors when mixing. They are good for glazing and for mixing strong darks. Some examples include: all quinacridones, all phthalos, and dioxazine purple.

Underpainting The first layer of paint on your canvas—it can be one solid color or multicolored

Blocking in Roughly setting up the big shapes in your painting without any small details

Value Shades of dark to light

High-key painting A painting with middle to light values

Low-key painting A painting with middle to dark values

Glazing A transparent layer of paint applied over all or part of a painting

Transitions Areas where the color or value shifts

Drybrush Application of paint with little or no water—creates a scratchy, textured look

Saturation The intensity of a color

Desaturation To soften the intensity of a color

Hue Another word for color

Lost edges When the outer edges of objects in your painting blend into the background

Calligraphy Thin, delicate lines

Monochromatic Painting

Using one main color in a painting allows you to really focus on the overall mood of the composition, as well as the values and texture.

Step 1 Start by painting your entire canvas with phthalo blue thinned with water. Once the canvas is dry, use white chalk to draw in the basic shapes. Then go over the chalk lines with phthalo blue paint.

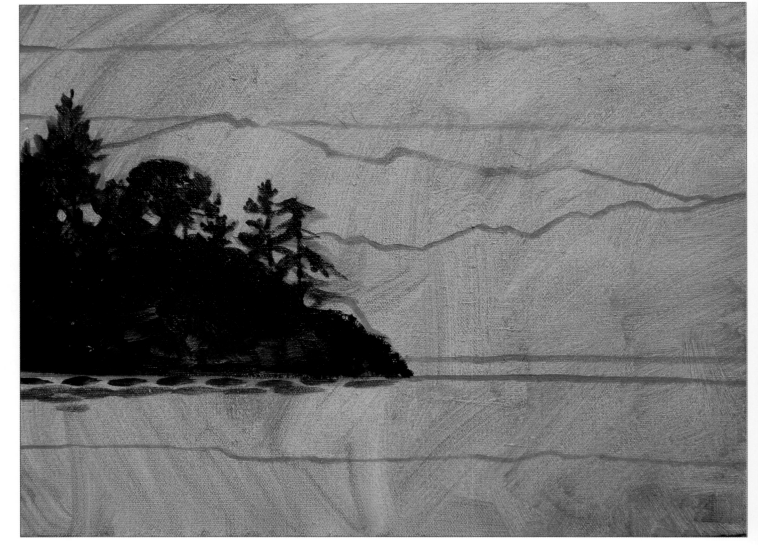

Step 2 For the closest island, mix phthalo blue with black to create a very dark blue. Put a little medium on your brush and mix it into the paint. Pay attention to the shapes of the trees, but keep everything fairly simple.

This liquid additive increases the fluidity of paint by breaking the surface tension. Unlike plain water, glazing medium helps preserve the strength of a paint color.

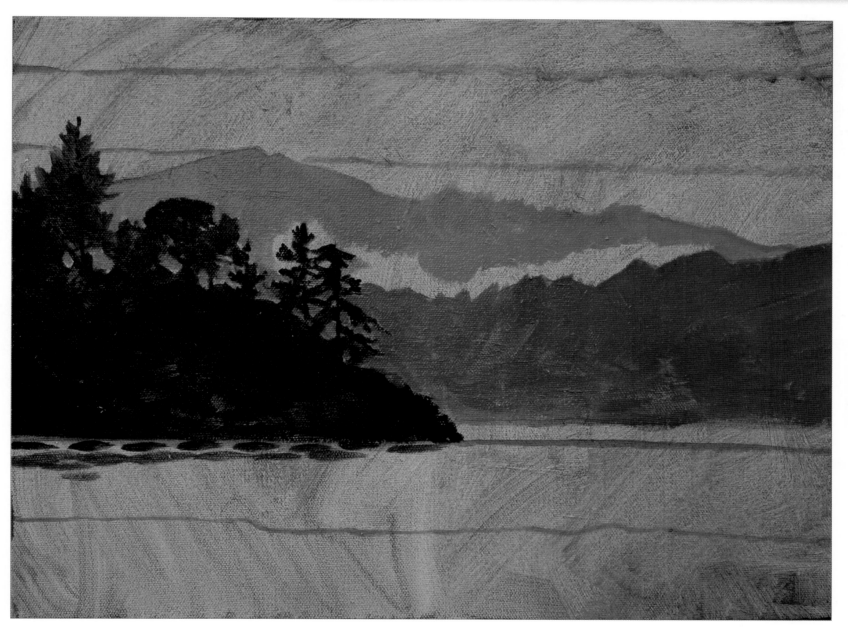

Step 3 For the background islands, add a bit of titanium white to phthalo blue to make a lighter value. Continue to add a little bit of medium to the paint mix, and use a brush that is damp, but not dripping. For the most distant island, add even more white to the phthalo blue. You will find that a little bit of white goes a long way.

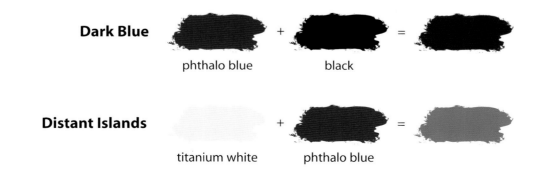

Dark Blue phthalo blue + black =

Distant Islands titanium white + phthalo blue =

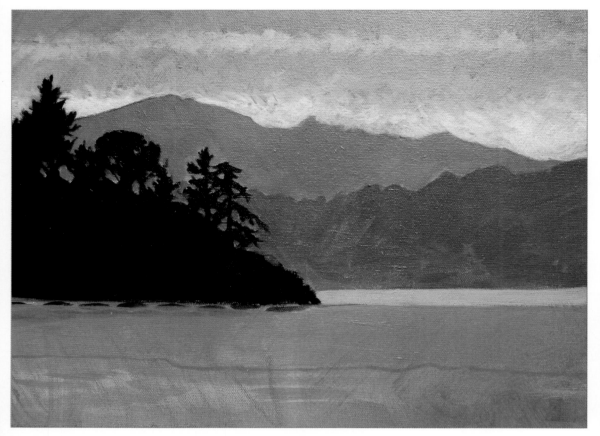

Step 4 Apply a second layer to the islands. For the sky, start at the lowest part, using mostly white and a tiny bit of phthalo blue. Using crosshatching brushstrokes, gradually add more blue as you work your way up. Build up a couple of layers until you are happy with the sky.

ARTIST'S TIP

When you paint around the trees, you can use the background color to help shape and define the trees. This is called "negative painting."

Add shading and texture to your work with crosshatching—layers of parallel lines placed over each other. Crosshatching creates texture in the sky, which contrasts nicely with the solid shapes of the islands.

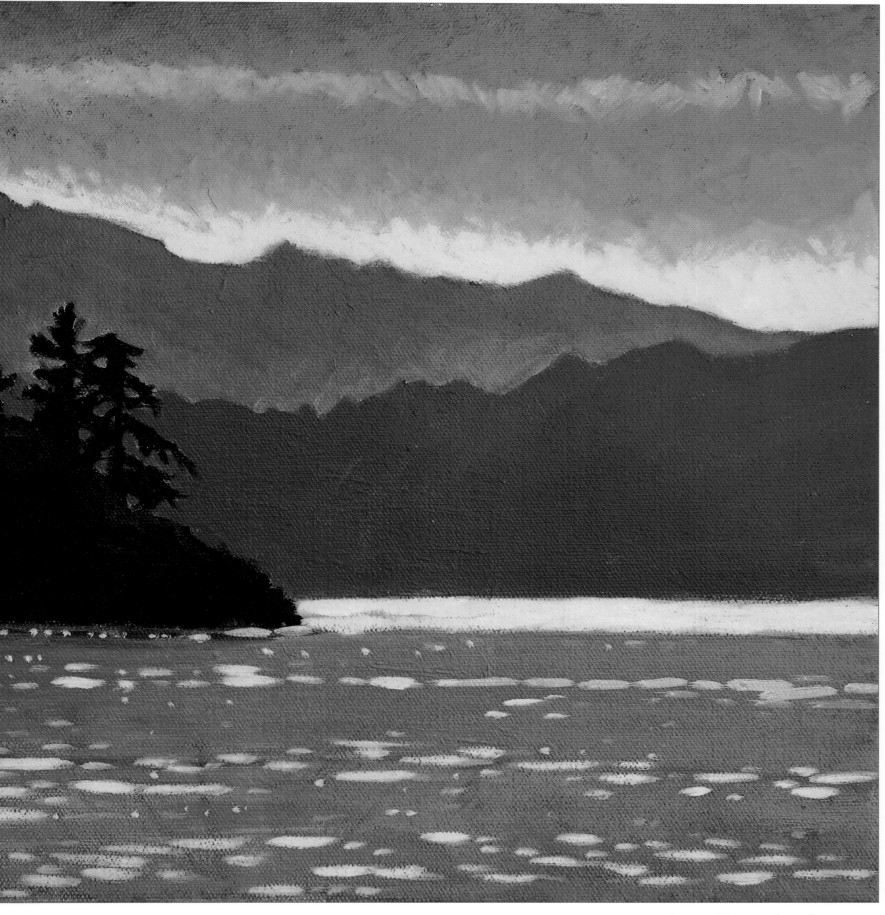

Step 5 To complete the composition, paint light lines in the water with white and a tiny bit of phthalo blue. Put one more layer on the lightest area of the sky. Add a tiny bit of white to your darkest island mix, and use this to paint a few highlights along the top edge of the island.

ARTIST'S TIP

Glazing liquid, or any other slow-drying medium, will keep acrylic paint wet a bit longer so that you can blend different colors together more easily.

CREATING AN UNDERPAINTING

An underpainting adds emotion and depth to any composition. By layering paint, you also create more texture, making the painting more interesting and attractive to the eye.

Step 1 Cover a 12" x 12" square canvas with two layers of Mars black. Once dry, use chalk to draw in the general shapes. Cover the chalk lines with cadmium yellow dark and titanium white for the flowers; ultramarine blue and white for the background, vase, and leaves; and pyrrole red for the apple.

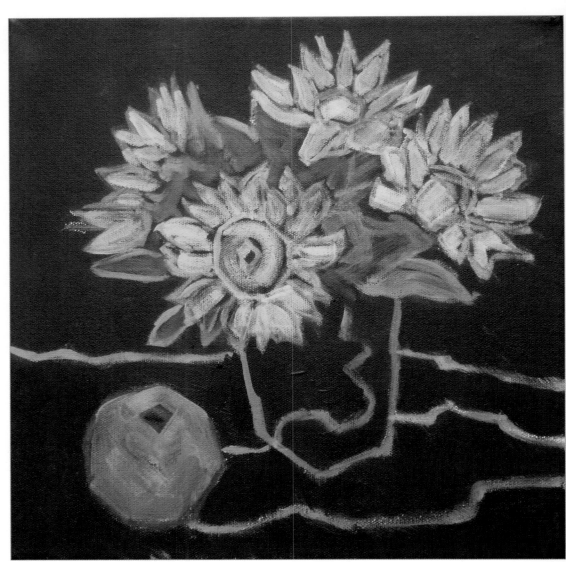

Step 2 Block in the shapes using the following mixes: cadmium yellow dark with a little white for the flowers; phthalo blue and cadmium yellow dark for the leaves; pyrrole red and cadmium yellow dark for the orange part of the apple; and cadmium yellow dark with a little phthalo blue for the green part of the apple.

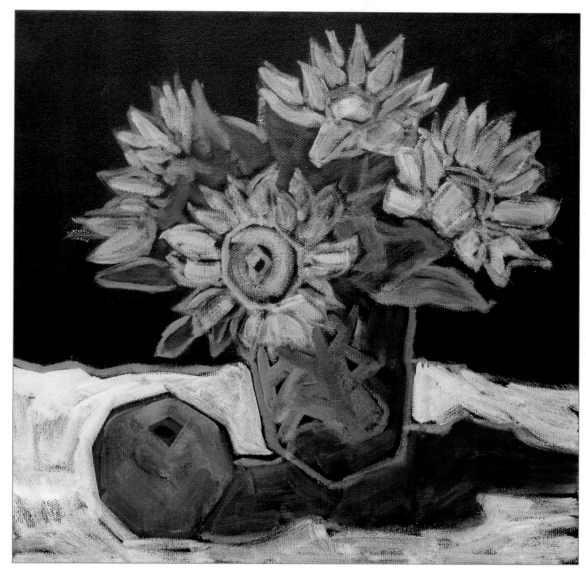

Step 3 Continue blocking in your base colors by painting the vase and shadow with ultramarine blue and white. Add more white for the lighter blue areas. Use mostly white with a little ultramarine blue for the tablecloth.

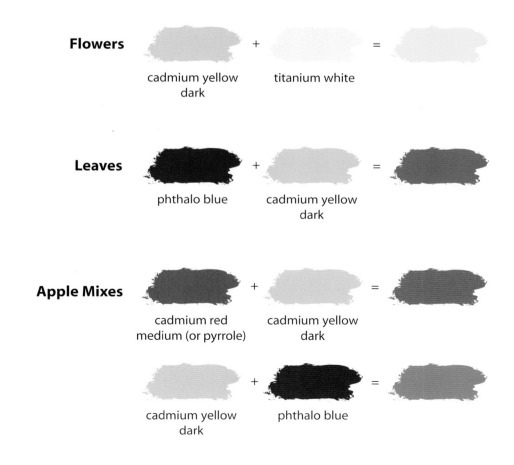

Flowers

cadmium yellow dark + titanium white =

Leaves

phthalo blue + cadmium yellow dark =

Apple Mixes

cadmium red medium (or pyrrole) + cadmium yellow dark =

cadmium yellow dark + phthalo blue =

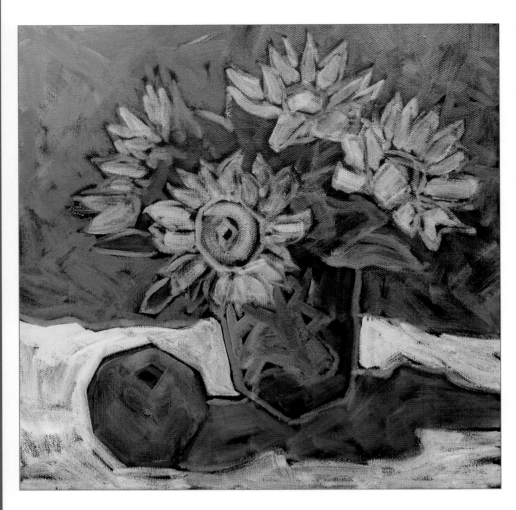

Step 4 Paint the background ultramarine blue and white. Use multidirectional brushstrokes to create texture. Add medium to the paint to keep it flowing smoothly.

Step 5 Define the flower petals with an outline of pyrrole red. Then block in each petal with a combination of cadmium yellow dark and pyrrole red. Next add lighter values of yellow to the front flower, using cadmium yellow dark and a little white. For the shadowed areas, add a little ultramarine blue to the red and yellow mix.

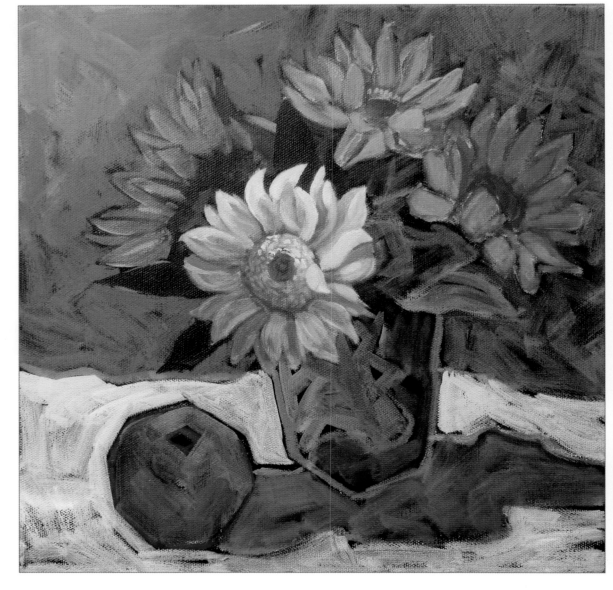

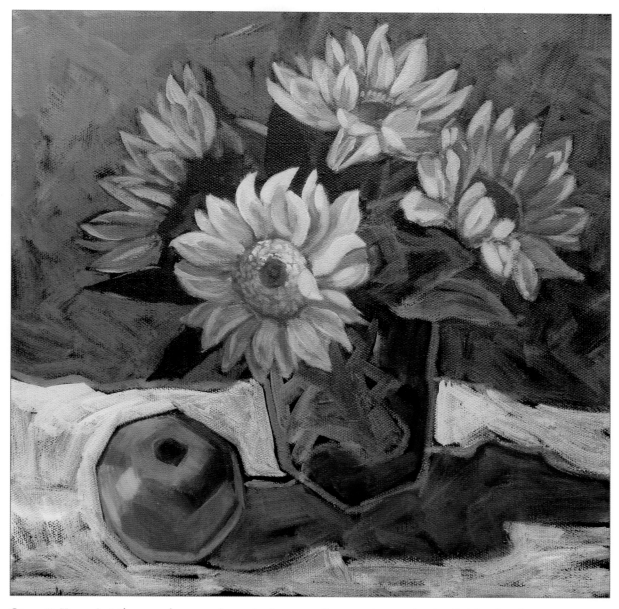

Step 6 To paint the apple, use slow-drying medium to keep the individual colors wet. Use combinations of cadmium yellow dark, pyrrole red, and phthalo blue, and use bold brushstrokes that follow the contours of the apple. For the dark center, use phthalo blue and pyrrole red.

ARTIST'S TIP

You can adjust the intensity of the blue in the background by varying the amount of white you add to it.

Step 7 Using the same colors, apply another layer to the background and the shadow of the vase. Paint the vase with ultramarine blue and white—more white for the lighter areas. For the apple stem, mix ultramarine blue, pyrrole red, and a bit of cadmium yellow dark. Paint a second layer on the darker areas of the leaves, using phthalo blue, cadmium yellow dark, and a little pyrrole red.

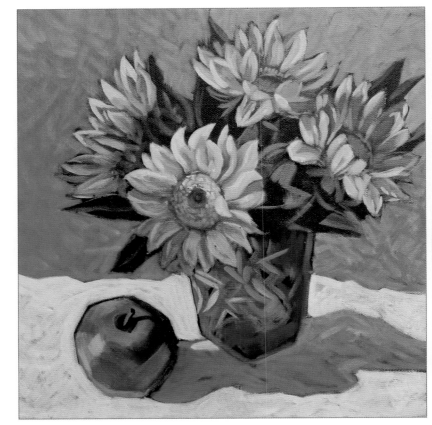

Leaf Mix		+		+		=	
	cadmium yellow dark		cadmium red medium (or pyrrole)		phthalo blue		

Apple Stem		+		+		=	
	ultramarine blue		cadmium red medium (or pyrrole)		cadmium yellow dark		

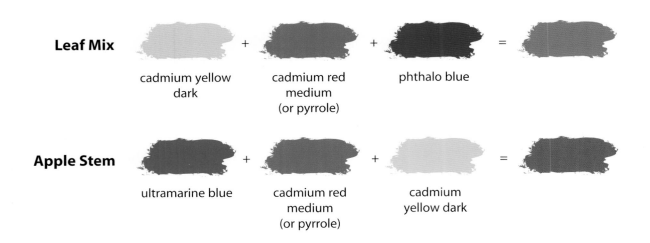

Layering Any areas of the painting that look unfinished can be painted over with more layers. Don't be afraid to layer. It will create more texture and make your composition more interesting.

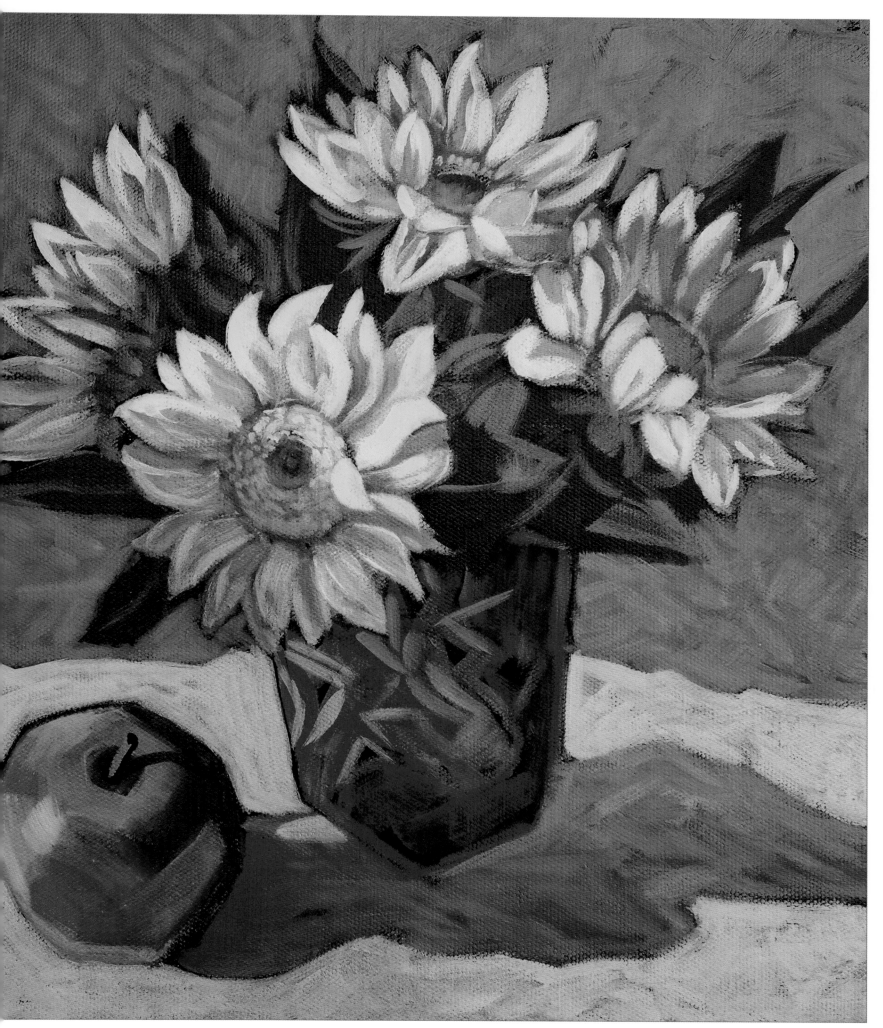

Step 8 Go over the vase one more time to make the patterns show. Paint in the shadow of the apple stem with ultramarine blue mixed with a little pyrrole red and cadmium yellow dark. Go over the tablecloth with a second layer of white mixed with a little ultramarine blue. Finish painting the leaves with a combination of phthalo blue, cadmium yellow dark, and white.

USING ARTISTIC LICENSE

You'll notice that the finished painting is not an exact replica of the reference photo. Artistic license allows you to put your own spin on a painting.

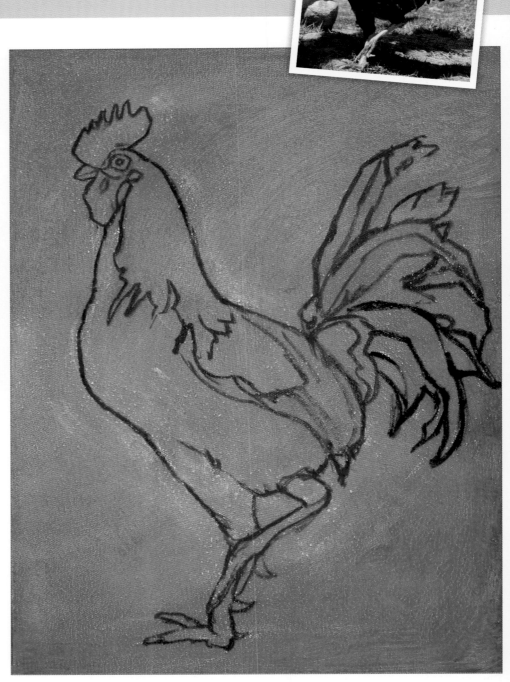

Step 1 Prepare a 12" x 16" canvas with a layer of quinacridone red. Dilute the color with a little water so it's not too dark. Once the paint is dry, draw in the main shapes of the rooster loosely with chalk. Try to fill the entire canvas.

Step 2 Once you are satisfied with your drawing, go over the chalk lines with phthalo blue. When the paint is dry, you can use a damp tissue or towel to wipe off the chalk lines.

ARTIST'S TIP
A trick to ensure your shapes are accurate is to turn the painting and the reference photo upside down. You can also look at your painting in a mirror.

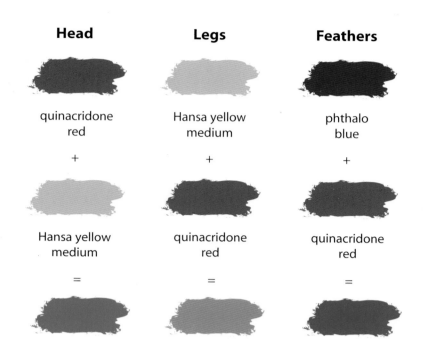

Head	**Legs**	**Feathers**
quinacridone red	Hansa yellow medium	phthalo blue
+	+	+
Hansa yellow medium	quinacridone red	quinacridone red
=	=	=

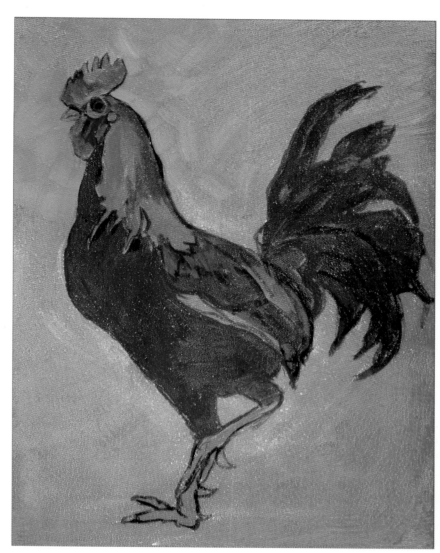

Step 4 Start on the next layer of background color. Using a mixture of blue, yellow, and white, apply the paint with a small flat brush. Change the direction of the brushstrokes in the background to create a broken square pattern.

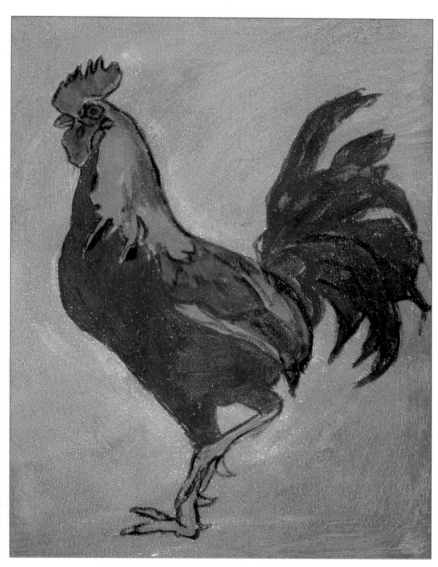

Step 3 Next block in the basic colors: red with a little yellow for the head, blue for the dark feathers, blue and red for the middle-value feathers, and yellow with a little red for the golden neck feathers and legs.

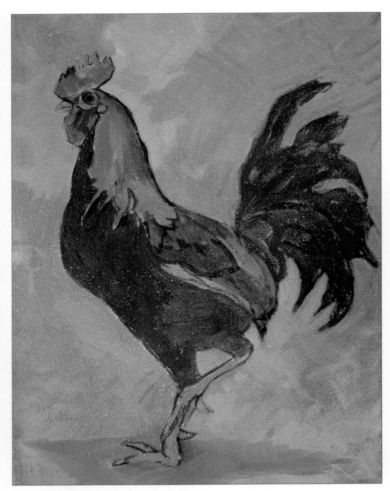

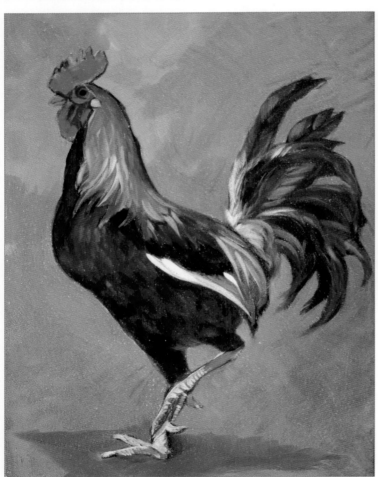

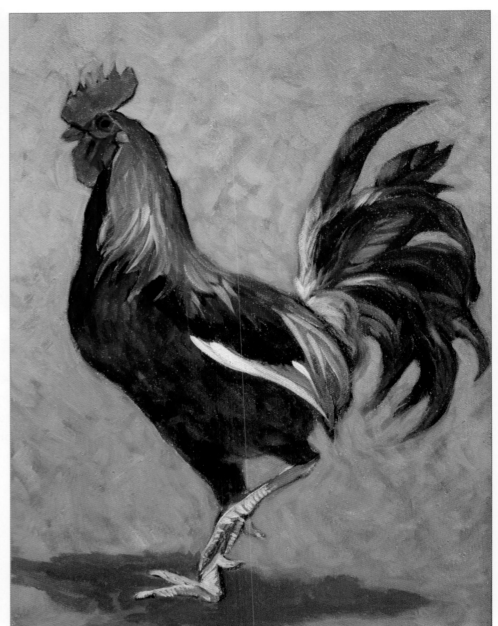

Step 5 Finish painting the background. Then start working on the shadow underneath the rooster, using a little less white with the blue and yellow mix.

Step 7 Paint a second layer on the background, using the same combination from step 4, but add a bit more yellow and white. Allow some of the first layer to show through to create texture.

Step 6 Use white paint to add details in the tail feathers and on the feet. Use yellow and white for the lightest feathers on the neck and back and a mixture of blue and red under the chest and in the dark areas of the head.

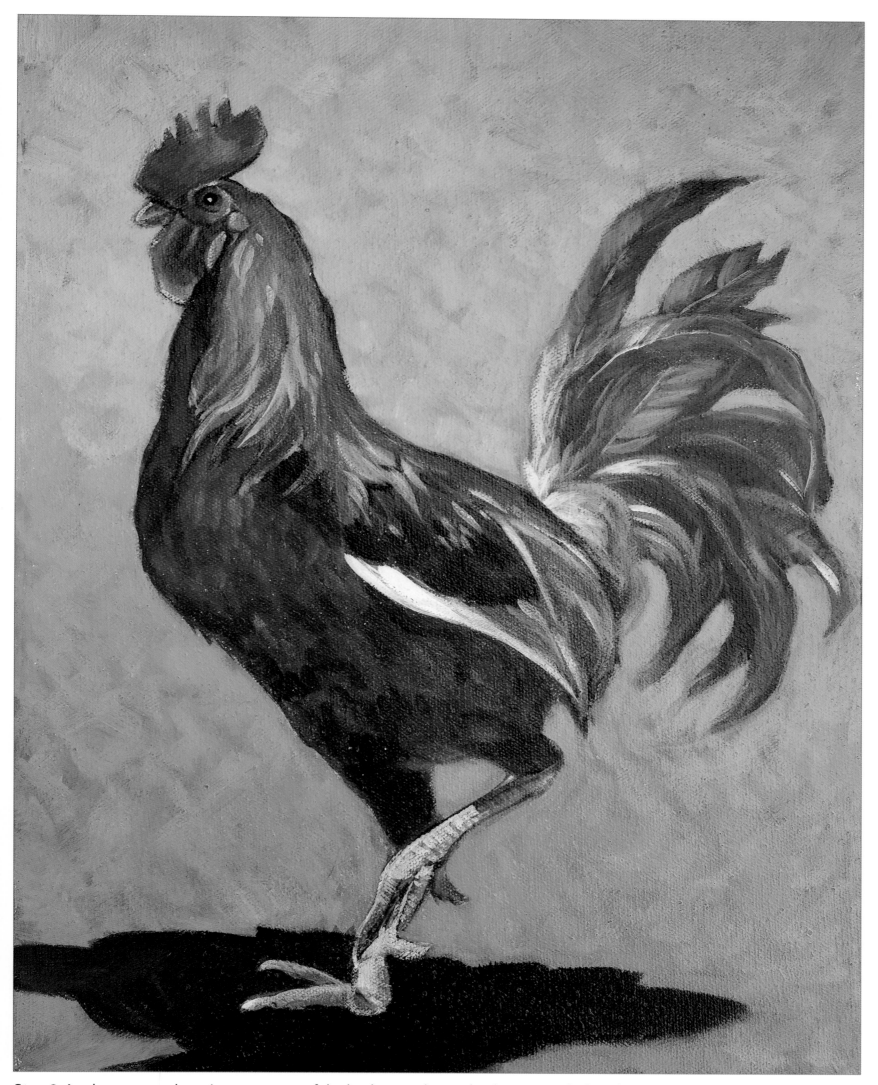

Step 8 Apply one more layer in some areas of the background to make the green a little softer. Add a second layer to the shadow as well, using blue, yellow, and a tiny bit of white and red. To finish, add a thin coat of yellow over the feet and a small circle of black with a tiny white dot for the eye.

CAPTURING NATURE

In nature, colors seem to become weaker and more subdued as objects recede into the distance. This is an important detail to keep in mind when painting a landscape.

Step 1 Start by painting your canvas with quinacridone nickel azo gold thinned with a little water. When the canvas is dry, draw in the main shapes with chalk. Then go over the chalk lines with ultramarine blue. Start with lines only to arrange the placement, height, and angles of each tree. Notice that the top line of the distant mountain starts a little lower down than the highest point of the foreground rocks.

ARTIST'S TIP
Adding glazing medium to acrylic paint slows the drying time, improves flow, and allows you to create glazes (see "Glazing" on page 21).

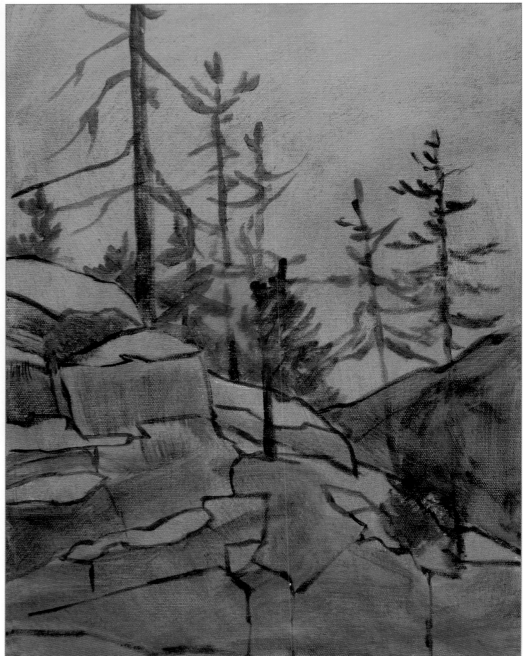

Step 2 Use blue, thinned with a bit of water and glazing medium, to paint the darker areas and to add the foliage on the trees.

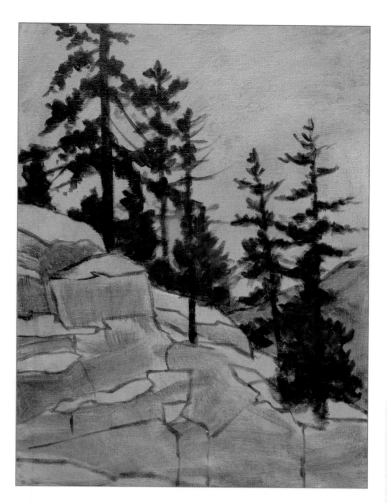

Step 3 Using a mix of blue and gold with a little glazing medium, add another layer to darken and define the foliage on the trees.

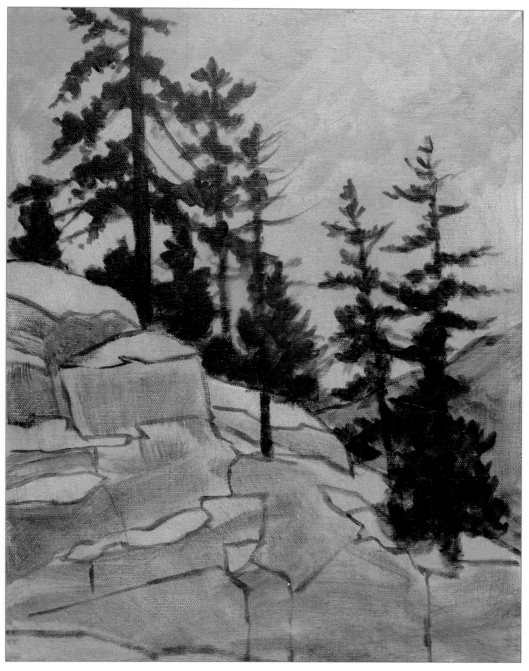

A *glaze* is a transparent layer of paint applied over another color. Shown here is ultramarine blue (left) and lemon yellow (right) over a mix of permanent rose and Naples yellow.

Step 4 For the sky, use a combination of blue and white. Start at the top, painting around the trees. Use short, multidirectional brushstrokes to create texture, and leave some areas so that there is variation.

21

Distant Mountain

ultramarine blue + Hansa yellow medium + titanium white =

Step 5 Finish the first layer of sky, and use negative painting to help shape the trees. Apply a second layer of paint to the trees, using blue, gold, and a tiny bit of white to make the paint more opaque. Add a second layer to the sky, and then paint the distant hill with a cool blue-green mix of blue with a little yellow and white.

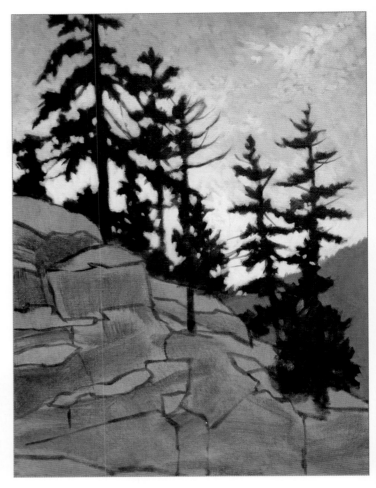

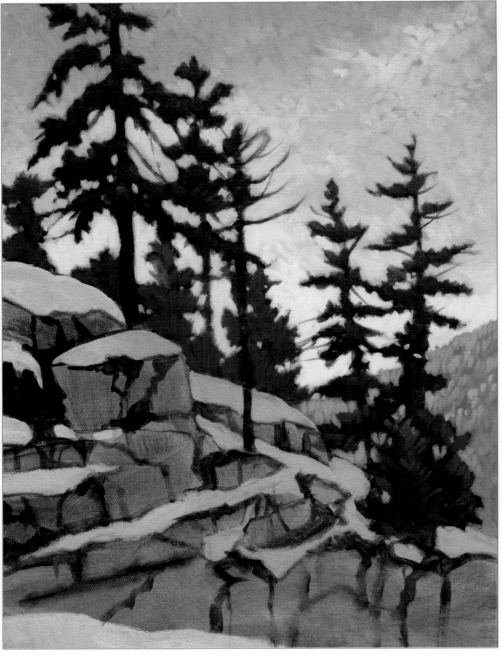

Step 6 Next paint the background trees with cool mixes to help them seem more distant. Use the same blue-green mix from step 5 to paint the closest background trees. Then mix blue with lots of white, and dab on short strokes to suggest trees on the distant hill. For the foreground trees, use blue with more yellow and a little white to make a warmer green. Also add a thin layer of white with a little blue in the snowy areas. With a small round brush, paint the dark, thick lines on the rocks with a mix of gold, red, and blue.

Foreground Trees Hansa yellow medium + ultramarine blue + titanium white =

Distant Trees ultramarine blue + titanium white =

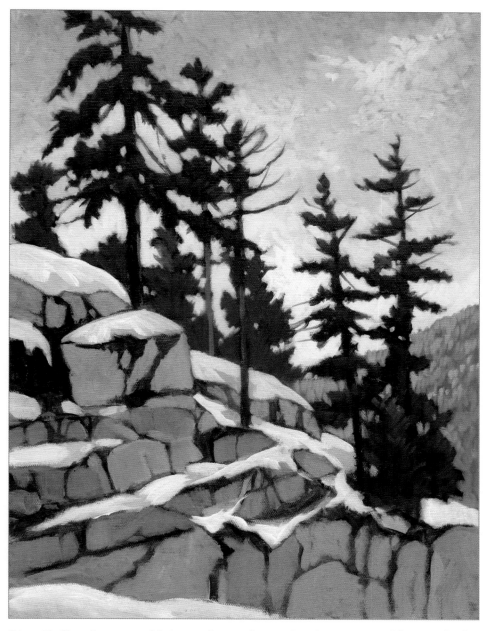

Step 7 Continue working on the rocks, and paint a second layer of white in the snow, leaving some of the original color showing for shadows.

ARTIST'S TIP

To establish some interesting color in the rocks, use various combinations of white with red, blue, and yellow to paint around the dark lines.

Step 8 To complete the painting, add one more layer of white on the snowy areas. Use blue, red, and yellow mixed with glazing fluid to deepen the color on the rocks. While the paint is still wet, paint in a little white in some areas—this technique is called painting "wet-into-wet." The white paint will pick up some of the color underneath it, adding depth and texture to the snow.

CREATING MOOD

Artists can create mood through color, subject matter, and composition. This nostalgic scene is accented by the fiery autumn colors of the trees and the reflections in the lake.

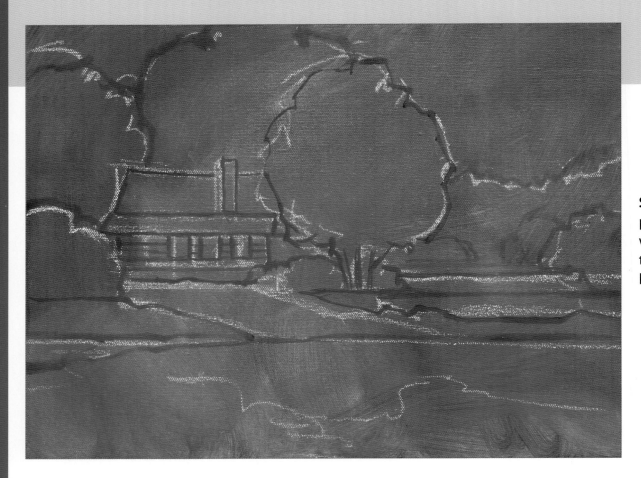

Step 1 Paint your canvas dioxazine purple. This is a strong color, so thin it with some water. Use chalk to draw in the basic shapes, and then go over the lines with blue paint.

Step 2 Start blocking in the basic colors. Mix red and yellow to make a vibrant orange for the middle and far left trees. Mix blue with a little yellow and a small amount of red for the darkest trees and shadowed areas. For the lighter trees, use more yellow in the green mix. Paint the grassy areas with yellow mixed with a tiny bit of white. Add orange and yellow to the middle tree.

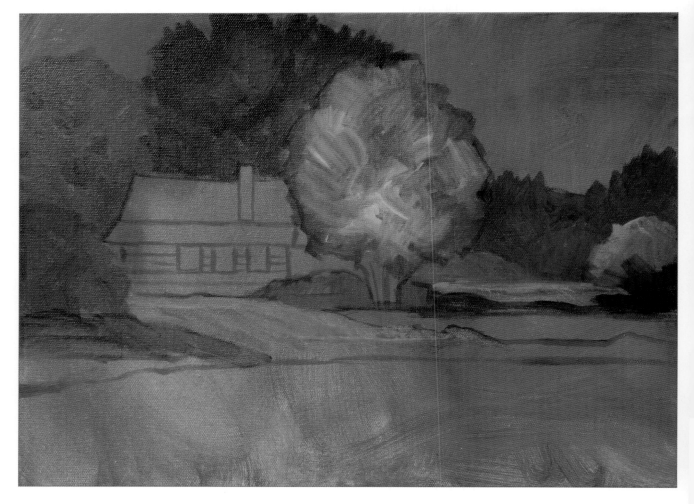

Foreground Tree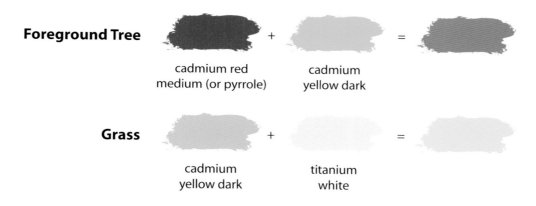

cadmium red
medium (or pyrrole) + cadmium
yellow dark =

Grass

cadmium
yellow dark + titanium
white =

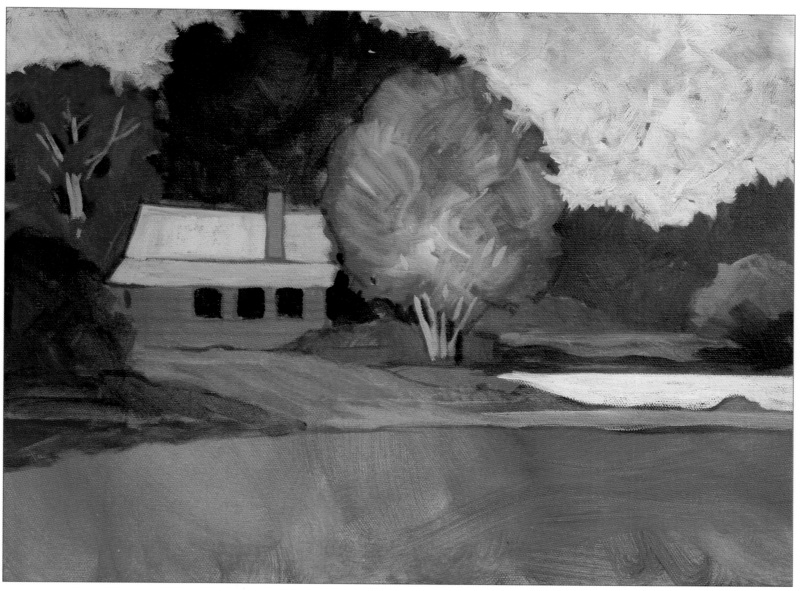

Step 3 Mix blue and white for the first layer of the sky. Paint the cottage roof with yellow mixed with a little red and white. Darken the tree on the far left with a layer of red, yellow, and a tiny bit of blue. For the cottage windows, use a layer of black.

Sky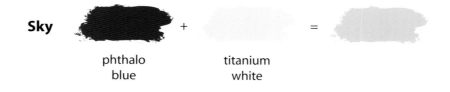

phthalo
blue + titanium
white =

ARTIST'S TIP

When painting the sky, make sure to paint around the shapes of the trees, maintaining their form and edges.

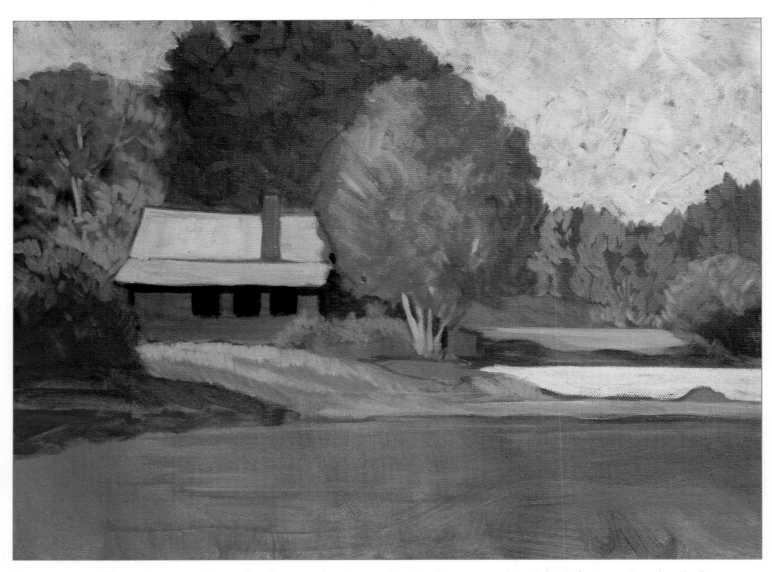

Step 4 Use different proportions of yellow and red to paint the foreground and far left trees. For the dark areas in the foreground tree, mix red with yellow and a little blue. Paint the green trees with various mixes of blue and yellow, adding some white for the most distant row of trees. Also put a second layer of yellow on the grassy areas. Mix red, yellow, and blue to paint the brown cottage, and paint the chimney using red and yellow.

Adding Texture
Vary the colors in the trees, and use short brushstrokes that resemble foliage.

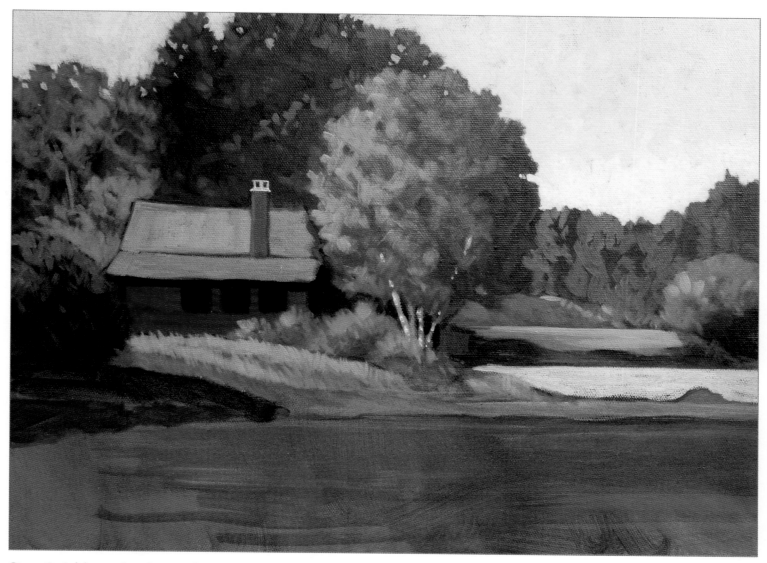

Step 5 Add another layer of paint to the sky, using blue, white, and a little bit of yellow. Using the sky color, create realistic-looking trees by placing some small spots of paint in the foliage. Continue adding more layers to the trees, using the same colors as before in varied proportions.

ARTIST'S TIP

Make the sky lighter at the bottom by using more white in the mix.

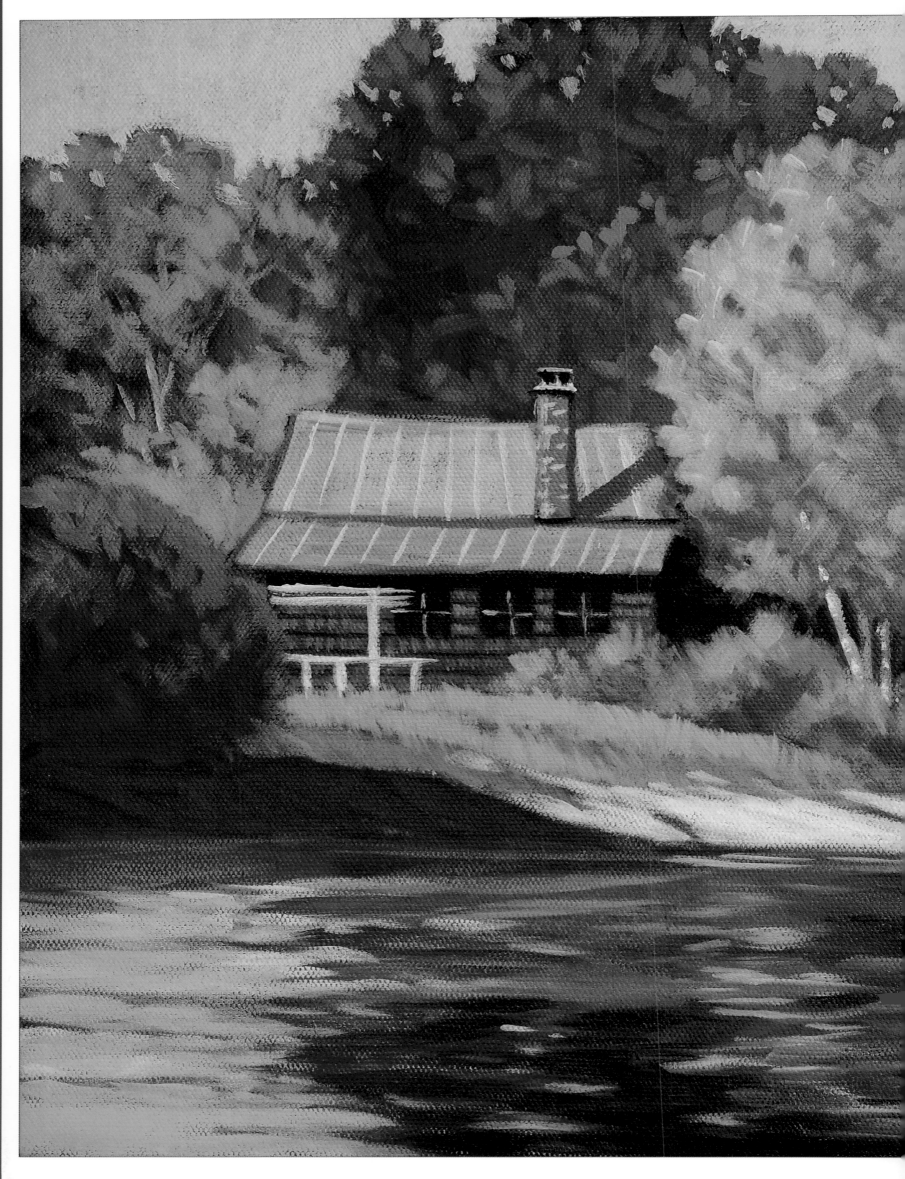

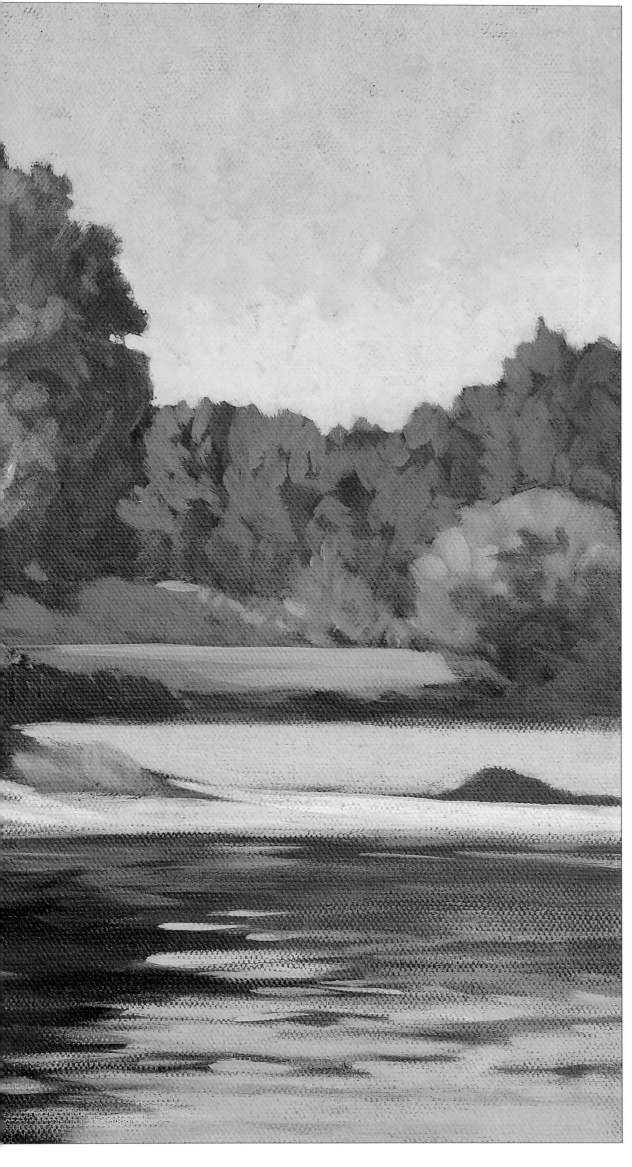

Step 6 Use white to paint in the details on the trellis and windows, and then paint a thin glaze of blue over the windowpanes to tone down the white. Dot some pale yellow on the chimney, and use this same color for the stripes on the roof. Paint the sand with yellow, white, and a tiny bit of red. Now focus on the water. First paint horizontal bands of blue and white. Paint the reflections on top of the blue using combinations of red, yellow, and blue plus white.

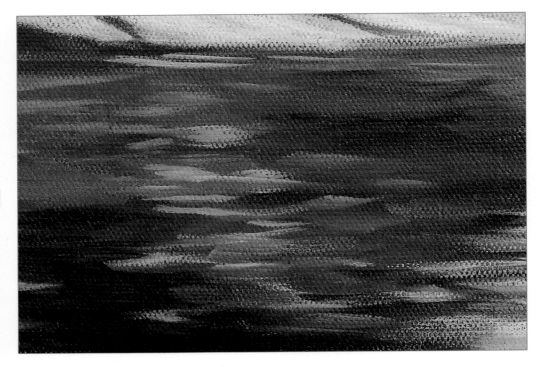

Adding Reflections in the Water
The reflections in the water mimic the top half of the painting. Notice how still the water is, evoking a feeling of peace and serenity.

Suggesting Texture Adding just a few lines creates detail and texture. Add a little more blue to the cottage mix from step 4 for the shingled pattern on the cottage wall.

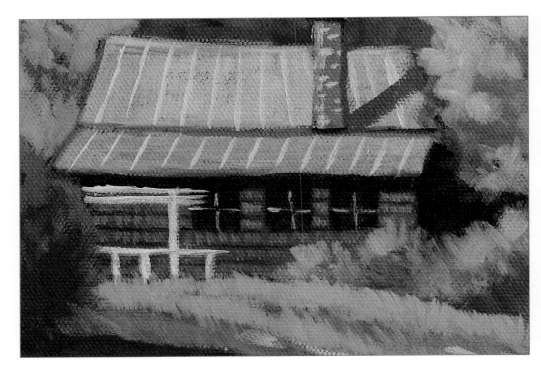

Detailing the Trees Strategically place the sky mix in the foliage to make the trees appear more realistic. It also helps bring the composition together, making it look more unified.